THE BOOK OF BENJAMIN

A 21ST CENTURY TIME CAPSULE OF POETRY, BARS & VERSES

FROM

VINCENT LEE BENJAMIN

THE BOOK OF BENJAMIN

PUBLISHED

BY

POETRY IN MOTION PUBLISHING

IN ASSOCIATION WITH

BIG ART PRODUCTIONS &
KING MONEY ENTERPRISES

SAVANNAH, GA USA 2024

ALL RIGHTS RESERVED. NO PART OF THIS BOOK MAY BE REPRODUCED, STORED IN A RETRIEVAL SYSTEM OR TRANSMITTED BY ANY MEANS ELECTRONIC, MECHANICAL, PHOTOCOPYING, RECORDING, OR OTHERWISE, WITHOUT WRITTEN PERMISSION FROM THE AUTHOR AT BIGARTPRODUCTIONS.COM

FEATURING

ZEN TALK

REFLECTIONS OF AN INNER SELF

ASSET MANAGEMENT

LONG STORY SHORT

CHAPTER I

ZEN

TALK

POETRY/BARS/VERSES

I. OM
II. IT'S A FREQUENCY THING
III. SAME DIRECTION
IV. FROM ME 2 U
V. DIVINE TIMING
VI. TURN AROUND TIME
VII. ALL GROW'D UP
VIII. WORK'N TOGETHER
IX. WTF
X. CLEANSE YOUR MIND
XI. THE HUMANITARIAN'S CREED
XII. IF
XIII. BIRD TALK

OM

THE SOUND OF THE UNIVERSE

...U CAN CURSE, SWEAR & YELL
ABOUT HOW LIFE CAN BE HELL
OR YOU CAN BE STILL
KICK BACK, RELAX & CHILL
AS U QUIETLY GO IN...
IT'S A MATTER OF CHOICE.
I PREFER TO BE AT PEACE
& USE MY INSIDE VOICE.

IT'S A FREQUENCY THING

ALL U HAVE TO SAY IS
NAMASTE

"THE DIVINITY IN ME SEES &
ACKNOWLEDGES THE DIVINITY IN U."
THAT'S ALL U HAVE TO DO.
BE A PART OF THE TRIBE
FEEL THE VIBE!

SAME DIRECTION

SOME FOLLOW A PATH LESS TRAVELED
SOME TRAVEL A PATH KIND OF HARD
SOME BELIEVE IN ALLAH - OTHERS
CHOOSE, JAH, JEHOVAH OR GOD
SOME FOLLOW THE WORDS OF MOSES
WRITTEN DOWN IN STONE AS LAW
SOME BELIEVE IN THE WORDS OF
MOHAMED AS HE TOLD OF THE VISION HE
SAW. SOME TAKE JESUS AS THEIR LORD
AND SAVIOR WHILE OTHERS CHOOSE
BUDDHA 2 UPLIFT SOULS AND ENLIGHTEN
BEHAVIOR. DIFFERENT PLANES -
DIFFERENT LANES, ALL HEADING IN THE
SAME DIRECTION, LET'S HOPE WE ALL GET
THERE SAFELY GUIDED BY
TRUE LOVE AND AFFECTION.

FROM ME 2 U...

FROM PERSONAL 2 UNIVERSAL –
WHEN U GO DEEP WITHIN
2 REVIEW
WHERE U ARE & WHERE YOU'VE BEEN
U IN EFFECT –
CONNECT 2 ALL HUMANKIND –
THE UNIVERSAL MIND
THE WIND THAT U CANNOT SEE –
BUT YET, FEEL IT'S FORCE –
THE POWER SOURCE...
THAT MAKES TREES BEND &
LEAVES FALL – THE CAUSE OF IT ALL.
FROM ME 2 U – FROM U 2 ME
U NOT ONLY BEGIN 2 FEEL –
BUT U BEGIN 2 SEE
THE CURRENT THAT FUELS
THE FIRES OF OUR DESIRES

& LIGHTS UP OUR PASSIONS
& CREATES OUR DREAMS –
THE REASONS BIRDS FLY SOUTH
& SALMON SWIM UP STREAM.
FROM UNIVERSAL 2 PERSONAL
IS WHERE WE ALL NEED 2 BE –
AS WE SHARE
THE SOURCE OF THE FORCE –
FROM THE BOTTOM OF THE OCEAN
TO THE STARS ABOVE –
FROM U 2 ME –
FROM ME 2 U…
THE GREATEST GIFT
IS
LOVE.

DIVINE TIMING

...RIGHT TIME, RIGHT PLACE
A LIFE FULL OF GRACE
WHEN YOU'RE IN TUNE
WITH THE MOON
AND AT ONE WITH THE SUN
MAKING THE RIGHT MOVES
WITH THE RIGHT INTENT -
IN LINE WITH THE MIND
OF THE DIVINE
BLESSINGS FLOW
AS IF HEAVEN SENT.

...WHEN YOU'RE DOING THE
RIGHT THINGS - NIGHT AND DAY
MIRACLES AND GOOD FORTUNE
WILL ALWAYS COME YOUR WAY –
AND YOU'RE NEVER LATE
WHEN IT COMES TO
YOUR DESTINY & FATE.
WHERE DO YOU START?
FOLLOW THE FEELINGS
OF YOUR HEART
WITH THE RIGHT FRAME OF MIND
AND YOU'LL ALWAYS BE...
IN THE RIGHT PLACE
AT THE RIGHT TIME.

TURN AROUND TIME

HOW LONG DOES IT TAKE
TO BAKE A CAKE... HOW LONG DOES
IT TAKE FOR AN EGG TO FRY –
HOW LONG DOES IT TAKE
FOR THE LACK OF HEAT
TO DEFEAT A DREAM & LET IT DIE.
DO U JUST KILL IT – GRILL IT –
PUT IT IN A SKILLET
STICK IT ON A BACK BURNER
& LET IT GO COLD...
BUT NEW IS OLD & OLD IS NEW –
IT'S TIME TO TAKE
THE HATE OFF THE PLATE
& MAKE A BRAND-NEW STEW –
MADE FROM LOVE,

PEPPERED IN PRAYER
& SAUTÉED IN SOUL -
ALL MIXED IN A BOWL...
LIKE BIG MOMMA USE TO DO -
WITH ENOUGH DOUGH
TO MAKE THAT CAKE RISE
RIGHT BEFORE OUR EYES
SO WE ALL COULD EAT –
WE ALL COULD COME TO THE TABLE
& HAVE A SEAT
IN THE SPIRIT OF UNITY, COMMUNITY,
JOY, HAPPINESS & HARMONY
...AND ENJOY LIFE'S MOVEABLE
FEAST -
I'M READY TO EAT!
HOW LONG DOES IT TAKE -
TO BAKE A CAKE...
CALLED **PEACE**.

ALL GROW'D UP

SINGED & BURNED
LESSONS LEARNED.
BEFORE YOU GO OUT
YOU HAVE TO GO IN
TO KNOW WHERE YOU ARE
WHERE YOU'RE GOING
& WHERE YOU'VE BEEN...
BECAUSE
IN THE BLINK OF AN EYE
YOU CAN CHANGE
THE COLOR OF THE SKY
FROM CLOUDY & GRAY
TO SUNNY & BLUE
JUST BY CHANGING
YOUR POINT OF VIEW

...FROM, IT'S NOT
WHAT'S IN IT FOR ME
BUT WHAT CAN I DO FOR YOU.
IT'S NOT WHAT I DESERVE
BUT HOW CAN I BETTER SERVE,
HOW CAN I HELP MANKIND -
HOW COULD I HAVE BEEN
SO BLIND
WHEN IT'S ALL
JUST A STATE OF MIND.
<u>TO GET WHAT YOU WANT</u>
FROM THE LIFE
YOU WISH TO LIVE...
<u>IT'S ALL ABOUT WHAT YOU GIVE.</u>
(LESSON LEARNED)

WORK'N2GETHER

1+1=2. 2X2=4.
WHEN YOUR TEAM
CROSSES THE GOAL LINE
U CALL THAT A SCORE.
U CAN DO THE HAPPY DANCE
AND ENJOY YOUR SUCCESS
YOU'VE MET THE CHALLENGE
AND PASSED THE TEST.
WHEN U WORK AS A TEAM
U CAN EASILY
ACCOMPLISH YOUR DREAM
WHEN U KEEP YOUR
EYES ON THE PRIZE

AND YOUR FEET ON THE GROUND
AND REALIZE THERE'S PLENTY OF
PEACE AND LOVE TO GO AROUND...

FROM FAMILY, FRIENDS, AND KIN
WHEN WE WORK TOGETHER
LAUGH AND PLAY TOGETHER
SHARE, CARE AND STAY
TOGETHER
LIVE, LOVE AND PRAY
TOGETHER –
FROM BEGINNING 'TIL END
THRU THICK AND THIN...
WE ALL WIN.

WTF
(WHY THE FROWN)

...WHEN YOU'RE ABOUT TO BURST,
READY TO CURSE –
THINK IT CAN'T GET ANY WORSE
STAY THE COURSE & KNOW THAT U
ARE CONNECTED TO THE SOURCE
THAT MAKES THE SUN SHINE
IN THE DAY
AND THE MOON GLOW AT NIGHT –
CHANGES DARKNESS INTO LIGHT
TURNS CAN'TS INTO COULDS
& WON'TS INTO WOULDS
& MAYBE NOTS INTO YES I SHOULD...
FEEL BLESSED TO EXIST
TO BE A PART OF ALL THIS –

TO HAVE ACCESS
TO AN ABUNDANT AMOUNT
OF LOVE, JOY,
HAPPINESS & BLISS.
JUST LOOK AROUND –
YOU SHOULD NEVER BE DOWN.
SO, WHEN YOU THINK
YOU CAN'T MAKE IT &
JUST DON'T WANT TO TAKE IT
& YOU'RE READY TO GO WILD...
JUST THINK TO YOUR SELF

WTF & SMILE.

CLEANSE YOUR MIND

WE DON'T RAP FAST –
WE TALK SLOW
BECAUSE WE'RE SAYING SOME
THINGS YOU NEED TO KNOW...
WE WANNA HELP YOU NURTURE YOUR
MIND & SEE YOUR LIFE GROW.
WE DON'T WANNA PREACH
WE PREFER TO TEACH
WE DON'T WANNA TELL YOU
HOW TO GET THRU IT
WE PREFER TO SHOW YOU
HOW TO DO IT.
SO HIT THOSE HOT SPOTS...
UNDER THE ARMS, AROUND
THE THIGHS BETWEEN
THE EARS & BEHIND THE EYES...

USE YOUR GRAY MATTER
TO MAKE YOUR POCKETS FATTER.
<u>CLEANSE YOUR MIND
OF NEGATIVE THOUGHTS</u>
TO GET THE THINGS THAT CAN'T BE
BOUGHT. USE YOUR IMAGINATION &
DETERMINATION AS YOUR
PRIMARY SOURCE OF INSPIRATION -
TO REACH YOUR HIGHEST HEIGHTS
& ULTIMATE DESTINATION.
DON'T LET DOUBT DIMINISH YOUR
DREAM -
BEFORE YOU FINISH YOUR SCHEME.
*<u>CLEANSE YOUR MIND
& SHINE</u>*

THE HUMANITARIAN'S CREED

MISSION STATEMENT

2 BROADEN MINDS
2 TOUCH SOULS
2 OPEN HEARTS
(...AND HELP REPAIR THE BROKEN PARTS).
2 RAISE & UNITE CONSCIOUSNESS & SPIRITS
2 BRING WARMTH 2 THE COLD
& COMFORT 2 THE OLD
2 FEED THE HUNGRY &
HOUSE THE HOMELESS
2 CALM THE ANGRY &
HELP EXCITE THE LIFELESS...
2 LIVE THEIR VERY BEST LIFE.

BOTTOM LINE -
2 BE A FOUNTAIN & NOT A DRAIN.
2 USE MY HEART,
MY SOUL,
MY BRAIN...
2 CREATE THE WORLD
I WISH 2 LIVE IN -
BY ADDING 2 THE MIX...
IF THEY ASK FOR 4, 5 OR 6
U GIVE THEM 7 -
BECAUSE A RISING TIDE
LIFTS ALL BOATS...
WE CAN ALL FLOAT -
WRAPPED IN A COAT
OF LOVE, JOY, PEACE, KINDNESS &
BLISS... AS WE ALL GET A CLOSER
GLIMPSE OF HEAVEN.

IF

IN THE MIDDLE OF LIFE
THERE COMES A BIG IF
AND IN THAT IF
THERE COMES A BIG RIDDLE –
AND IN THAT RIDDLE LIES ANOTHER
GREAT GIFT – ANOTHER BIG IF
WHICH IS THE ANSWER TO THE RIDDLE
IN THE MIDDLE OF LIFE.
BECAUSE IF U DECIDE TO USE YOUR
GIFT OF LIFE 2 BRING JOY AND
HAPPINESS AND PEACE AND LOVE
AND KINDNESS TO EVERYONE YOU
MEET – YOUR EXISTENCE WILL HAVE
MEANING AND PURPOSE AND YOUR
GIFT TO LIFE WILL BE COMPLETE.

BIRD TALK
('CAUSE I'M HAPPY)

WHAT'S THE WORD HUMMINGBIRD?
WHAT 'CHA KNOW –
OLE BLACK CROW?
WHY? - - - BUTTERFLY.
ROBIN RED
WHAT'S IN YOUR HEAD
...WHAT HAVE YOU HEARD?
ASK THE HUMMINGBIRD?
... BUT THE HUMMINGBIRD
HASN'T SAID A WORD...
SHE JUST HUMS.

CHAPTER II

REFLECTIONS OF AN INNER SELF

POETRY/BARS/VERSES

I. REFLECTIONS OF AN INNER SELF
II. CURSES
III. THE HUMAN ME
IV. GOD KNOWS
V. AT THE BOTTOM OF THE HILL
VI. GOING PLACES
VII. I AM
VIII. HURDLES
IX. PASSION
X. I.N.C.
XI. RELATIVELY SPEAKING
XII. COGITO ERGO SUM
XIII. TRUE NATURE
XV. IS THAT ALL THERE IS
XVI. R.A.P. RUSHING A POET
XVII. RHYTHM OF LIFE

REFLECTIONS OF AN INNER SELF

...WHEN THE OUTSIDE U
MEETS THE INSIDE U
AND THEY REFLECT –
WITH THE INSIDE SELF
BEING ALL PURITY AND LIGHT –
MAKES THE OUTSIDE SELF
JUST AS BRIGHT.

SHINE ON.

CURSES

WHEN YOU CURSE
ANOTHER,
BE IT FRIEND, FOE OR LOVER...
MOTHER, FATHER,
SISTER OR BROTHER...
YOU CURSE GOD & YOURSELF...
BECAUSE GOD IS YOU
& EVERYONE ELSE.
SO CONSIDER THAT FACT
NEXT TIME YOU ACT
NEXT TIME YOU REACT...
IF YOU SPEW HATE
THAT'S WHAT YOU'LL GET...
BUT IF YOU GIVE LOVE...
YOU GET LOVE BACK.

THE HUMAN ME

...WANTS REVENGE
WANTS PAY BACK...
WANTS TO TAKE ACTION
FOR ITS DISSATISFACTION...
WANTS TO HURT... THROW DIRT...
SLANDER, MAIM AND MALIGN...
THE HUMAN ME
WANTS TO BE RIGHT...
ALL THE TIME.
THE HUMAN ME...
DECEIVED, CHEATED & LIED...
BUT THE HUMAN ME...
MET THE SPIRIT ME,
MET THE GOD IN ME
& BECAME RELIEVED,
RETREATED & DIED.

GOD KNOWS YOUR HEART

PRAY TO GOD TO KNOW GOD
BECAUSE GOD ALREADY KNOWS U...
WHY ASK GOD FOR WHAT U WANT,
WHAT U NEED
OR WHAT U NEED TO DO...
GOD GAVE U YOUR LIFE,
YOUR BREATH,
YOUR THOUGHTS...
GOD KNOWS YOUR FUTURE,
YOUR PRESENT & YOUR PAST...
GOD KNOWS WHAT YOU WANT,
NEED & DESIRE BEFORE
YOU HAVE TO ASK.

GOD DOESN'T GIVE BASED
ON HOW U SERVE
OR WHAT U THINK U DESERVE...
GOD GIVES ALL – TO ALL –
AT ALL TIMES...
WE JUST HAVE TO OPEN UP THE WINDOWS
& DOORS TO OUR SOULS & OUR MINDS...
& DO OUR PART -
PRAY TO GOD TO KNOW GOD
BECAUSE GOD LOVES U
&
TRULY KNOWS YOUR HEART

AT THE BOTTOM OF THE HILL

...IS WHERE WE START
STOP AND RESTART AGAIN
WHERE WE FALL DOWN & REFLECT...
ON WHERE WE'VE BEEN,
WHERE WE'RE GOING
AND WHERE WE COME FROM.
A CHANCE TO START OVER
A LITTLE MORE WISER &
A LITTLE LESS DUMB...
& REALIZE THAT THE BOTTOM OF
THE HILL IS NOT OUR LAST STOP -
JUST A NECESSARY JOURNEY
ON OUR WAY
BACK TO THE TOP.

GOING PLACES

THE MORE U GO
THE MORE U KNOW-
THE MORE U KNOW
THE MORE U SHOW
&
THE MORE U SHOW
WHAT U KNOW
THE MORE U KNOW
WHERE TO GO
& THE MORE U SHOW
THAT U KNOW WHERE TO GO
THE MORE YOU'LL KNOW
HOW TO DEAL & WHAT TO FEEL
ABOUT ALL THINGS FALSE
& ALL THINGS REAL.

I AM

I AM THE CLOUDS I AM THE SKY
I AM THE GROUND, THE GRASS, THE TREES.
I AM THE BREEZE... I AM AT EASE.
I AM THE SPRING RAIN & THE SUMMER
SHOWER I AM THE SOURCE OF ALL POWER.
I AM THE SPACE BETWEEN DAY & NIGHT
I AM THE LEFT – I AM THE RIGHT...
I AM THE LIGHT.
I AM HEALTH, I AM WEALTH
I AM STRONG, I AM SMART
I AM SCIENCE, I AM TECHNOLOGY
I AM MUSIC, I AM ART
I AM THE ROCK, THE STEEL, THE WOOD
I AM ALL THAT IS GOOD.

I AM THE OCEAN, THE RIVER, THE STREAM
I AM WHAT I DREAM.
I AM ALL THERE IS &
ALL THERE WILL EVER BE
I AM EVERYTHING U FEEL, SENSE OR SEE
I AM MY HIGHEST SELF...
I AM THAT NOW.
I AM CREATION, I AM IMAGINATION
I AM EVERYTHING BELOW,
I AM EVERYTHING ABOVE
I AM KNOWLEDGE, I AM TRUTH
I AM PEACE...
I AM LOVE.

HURDLES

HAVE U EVER RUN THE HURDLES
MOVIN' REAL FAST
WAY OUT FRONT
TRAVEL'N FIRST CLASS
COUNTING THE VICTORY
BEFORE THE RACE WAS WON
CONQUERING THE HURDLES
ONE BY ONE GLOWING WITH EGO
LIKE THE NOON DAY SUN
LEAVING THE REST AT THE STARTER'S
GUN - DOING THE HURDLES ONE BY ONE
UNTIL U TRIPPED ON THAT EGO
AS THE OTHERS RAN PAST -
DOING THE HURDLES
& MOVIN' REAL FAST.

PASSION

...WHAT U FEEL
WHEN U DON'T WANT TO FEEL
WHEN U CAN'T STOP
FROM EXPRESSING YOURSELF
STATING YOUR VIEW
BE IT ON LOVE OR HATE
WHEN U CAN'T WAIT
TO GET IT OFF OF YOUR CHEST
NO TIME FOR DIPLOMACY OR TACT
WHEN YOU'RE CONTROLLED BY PASSION
YOU'RE COMPELLED TO ACT.

I.N.C.

...HAD A FRIEND WITH A MASTER PLAN
TO INCORPORATE ME INTO THEIR
CORPORATE PLAN...
TO CHECK OUT WHERE
I WAS STRONG
AND TO HELP ME REACH MY PEAK...
TO KNOW WHAT I'VE DONE WRONG
AND USE IT TO KEEP ME WEAK...
TO UTILIZE MY POWERS OF OBSERVATION
FOR THE BETTERMENT OF THEIR
CORPORATION - BUT WHAT MY CORPORATE
FRIEND FAILED TO SEE –
IS THAT I'M A UTILIZER
AND NOT A UTILIZEE...
I'M NOT CONFORMING

I.N.C.

RELATIVELY SPEAKING

R U SOMEBODIES
LITTLE SISTER
OR BIG BROTHER
OR GREAT AUNT
OR WIFE
OR HUSBAND'S
MOMMA'S - DADDY'S
2ND COUSIN?
WHO DO YOU BELONG TO?
WHOSE BLOOD
IS IN YOUR VEINS?
MY BLOOD IS RED.
I GUESS WE'RE RELATED.

COGITO ERGO SUM*

I'M A THINKER
DON'T YOU KNOW
SOMETIMES QUICK
SOMETIMES SLOW

NOT THE WORST
NOT THE BEST
BUT A THINKER
NONE THE LESS.

*I THINK THEREFORE I AM

TRUE NATURE

...GOT LOUD 2 DRAW A CROWD
BECAUSE I NEEDED YOUR ATTENTION
I HAD A FEW THINGS ON MY MIND
THAT I NEEDED 2 MENTION,
SOME THINGS THAT WERE
CAUSING ME TENSION.
NOW THAT I'VE SPOKEN MY PEACE AND
SAID WHAT WAS NEEDED 2 BE SAID IT'S
TIME 2 PUT THIS BABY 2 BED. I'VE HAD MY
SAY, SO GOODBYE, SO LONG, ADIOS, CIAO,
SEE U – HAVE A GREAT DAY – IT'S TIME 4
FOR ME 2 FADE AWAY I'M HEADING *IN*
...I'M GOING BACK 2 BEING
- *QUIET AGAIN.*

IS THAT ALL THERE IS...

TO THIS WHOLE SHA-BANG
JUST HANG'N OUT WITH THE GANG...
PARTYING WITH THE GUYS & GIRLS IS
THAT ALL THERE IS TO THIS WORLD...
MAKING NOISE IN PURSUIT OF TOYS...
THINGS MADE OF PAPER, PLASTIC & TIN...
THINGS WE HAVE TO HAVE & SO
DUTIFULLY DEFEND & IN THE END
WILL ALL BE GONE...
WHEN WERE LEFT ALONE
WITHOUT EVEN OUR SKIN
(ASHES TO ASHES DUST TO DUST)
...TO HIDE IN -
TO PROTECT US FROM THE COLD
...ALL WE'LL HAVE LEFT IS OUR SOUL.

RUSHING A POET
(R - A - P)

NO NEED TO RUN IT BY SO FAST
LET IT LAST - LET IT FLOW SLOW
MAKE IT MELLOW KEEP IT LOW
I WANNA BE SURE
(I LIKE THE BEAT)
BUT I LIKE THE WORDS MORE.
SO POET I WANT YOU TO KNOW IT
RAP IS COOL - REAL NICE
IT HAS ITS PLACE
BUT FOR A MIND BENDING NEVER ENDING
ALWAYS MEMORABLE VERBAL RIDE ON
THE CEREBRAL SIDE
DON'T... RUSH - A - POET
JUST FOLLOW THEIR PACE.

THE RHYTHM OF LIFE

GOD IS ME AND I AM GOD
ALL THAT HE IS I AM
ALL THAT I AM HE IS
HE'S A SHE - SHE'S A HE
GOD IS ME.
GOD IS MY FATHER MY MOTHER
MY SISTER, MY BROTHER
GOD IS... EVERYONE EVERYWHERE
DOING EVERYTHING ALL THE TIME
IT'S A RHYME...

CHAPTER III

ASSET MANAGEMENT

...A POETIC GUIDE TO ECONOMIC EQUANIMITY

POETRY/BARS/VERSES

I. ASSET MANAGEMENT
II. MONEY CLIP SLIP
III. DON'T LET MONEY BE
IV. NO NO HIT AND RUN DRIVER
V. HOW TO MAKE A BUCK
VI. MONEY MATTERS
VII. ROAD DOG
VIII. NO MONEY IN THE CURE
IX. LIFE
X. ALL IN
XI. THIS AND THAT
XII. COUNT YOUR BLESSINGS
XIII. TAKE THE NOT OUT
XIV. HARD HEAD ED
XV. DRIVE
XVI. LOOSE'N UP

ASSET MANAGEMENT

STOCKS RISING
SHARES HOLDING STRONG
EVERYTHING MOVING SMOOTHLY
ALONG.
PORTFOLIO FLUFFY,
INVESTMENTS INTACT
TOOK CARE OF MY TAXES

EVEN GETTING MONEY BACK.
INVESTING IS EZ
WHEN U DO IT WITH GOOD
INTENT
I INVESTED IN THE POWER OF LOVE
MY MONEY WAS WELL SPENT.

MONEY CLIP SLIP

I HAD A KNOT
NOW I DO NOT...
MY PERSONAL STOCK
HAS SUFFERED A LOT
IT'S TAKEN A SERIOUS DIP
(SO HAS MY CLIP)
IT'S BEGUN TO SLIP
IT WILL NO LONGER HOLD
WHAT I HAVE TO FOLD
IT'S KINDA COLD
BUT IT'S A STORY
THAT NEEDS TO BE TOLD
MY CLIP HAS LOST IT'S GRIP
IT'S FALLEN VICTIM
TO THE MONEY CLIP SLIP.

DON'T LET MONEY BE YOUR HIT & RUN DRIVER

BEEN RUNNING INTO PLENTY OF MONEY -
ME & MY HONEY
BEEN HAVING BIG FUN -
BUT NOW...
I AIN'T GOT NONE
(I DON'T HAVE ANY - NOT A PENNY)
THE MONEY DONE RUN
GOT UP & SPLIT (*#!?*#!)
MADE A HIT - SHOOT!
I NEED SOME LOOT -
CAN I BORROW A BIT
OR MAYBE A FIVER -
'CAUSE MONEY
DONE BEEN MY HIT & RUN DRIVER!!!

HOW TO MAKE A BUCK THE AMERICAN WAY

PSST... PSST... HEY MAN –
DO U HAVE A FEW? IF U DO –
I'D VERY MUCH LIKE TO TALK TO U
IT'S ALL ABOUT SOMETHING THAT I DID –
ALL BASED ON THE POWER
OF THE PYRAMID.
U SEE I GOTTA PLAN,
A HELLUVA PLAN
ONE SURE NOT TO MISS
BECAUSE IT GOES LIKE THIS –
...U TAKE A LARGE SUM OF MONEY
& U PUT IT IN MY HAND
THEN U FIND ANOTHER MAN
TO KICK IN ANOTHER COUPLE OF GRAND
THEN I'LL TAKE THIS MONEY
IN MY HAND & BUY ME SOME LAND
& ON THIS LAND I'LL BUILD ME A HOME

ONE WITH A GOLD & SILVER DOME
THEN I'LL WRITE ME A BOOK
ABOUT WHAT IT TOOK
TO OBTAIN MY RICH
& SOPHISTICATED LOOK
& THEN FOR A NOMINAL FEE
JUST BETWEEN U & ME – U CAN GET IT ON
THE LOW- LOW… DON'T SAY NO, NO –
JUST LISTEN TO MY PITCH THERE'S NO
HITCH – I'LL TALK FAST – U WALK SLOW –
ARE U HIP TO CRYPTO –
IF SO – LET ME TELL U ABOUT SOMETHING
THAT I DID – ALL BASED ON THE POWER OF
THE PYRAMID – U SEE I'VE GOT A PLAN
A HELLUVA PLAN –
ONE SURE NOT TO MISS
BECAUSE IT GOES LIKE THIS…

MONEY MATTERS

NO IFS ANDS OR BUTS
WITHOUT THE PAPER U CAN'T MAKE THE
CUT... U CAN'T BE A PART OF THE TEAM –
U CAN'T LIVE OUT YOUR DREAM –
U CAN'T GET ON – U CAN'T CATCH –
IF U AIN'T GOT THAT SCRATCH
TO SOOTH THAT ITCH, IF U POOR & AIN'T
RICH LIFE'S A BOTTOMLESS DITCH
THAT U CAN'T GET OUT
BECAUSE IF U AIN'T GOT THAT MONEY
U AIN'T GOT NO CLOUT - NO SAY
IF U CAN'T PAY - THEY WON'T EVEN
LET U PLAY - SO IF U WANT TO WIN
U NEED MONEY TO SPEND
TO BE ABLE TO PUT YOUR LINE IN THE
WATER IN ORDER TO CATCH THE BIG FISH -
IT TAKES MORE THAN A WISH -
IT TAKES PAPER TO MAKE A DREAM COME
TRUE... *MONEY MATTERS* - SO GET YOUR
GRIND ON
& DO WHAT U GOTTA DO...

ROAD DOG

WHEN MOVING, SHAKING
& MONEY MAKING
WITH GOOD INTENTIONS
& DETERMINATION
RELAX TO THE MAX
BECAUSE GOD'S GOT YOUR BACK...

IF YOU FLIP THE SCRIPT
& TURN THE DOG AROUND
WHO & WHAT DO YOU SEE...

G. O. D.

(DON'T LEAVE HOME WITHOUT 'EM)

NO MONEY IN THE CURE

...IT PAYS TO BE SICK
IT'S AN OLD DEALERS TRICK...
THEY WANNA KEEP YOU COMING
BACK BECAUSE WHEN IT COMES
TO MAKING MONEY...
CANCER IS JUST LIKE CRACK.
IF YOU GET WELL
THERE'S NOTHING TO SELL,
NO ILLS - NO PILLS
NO BILLS...
NO REASON TO PAY –
THAT'S WHY THERE'S
NO MONEY IN THE CURE...
BECAUSE THE CURE
WOULD JUST GET IN THE WAY.

LIFE...
ON THE CORNER

LIFE - LIKE A ROLL OF THE DICE
CAN TAKE A LOT OF TURNS, TUMBLES &
UNCERTAIN CIRCUMSTANCES.
THEY'RE BOTH THE SAME A NUMBERS
GAME FILLED WITH GAMBLES, RISKS &
CHANCES. BUT IF YOU ROLL DON'T
BET YOUR SOUL OR LOSE CONTROL
WITH THE CHANCES THAT U TAKE –
BECAUSE THERE'S A COST TO BE THE BOSS
- AND A PRICE TO PAY
FOR THE DECISIONS THAT U MAKE.
SO BEFORE U SHOOT
& PUT EVERYTHING ON THE LINE -
THERE'S SOMETHING TO KEEP IN MIND...
A TOPIC FOR INTERNAL & EXTERNAL
DISCUSSIONS... BECAUSE LIFE -
LIKE A ROLL OF THE DICE
COMES WITH A PRICE
CALLED CONSEQUENCES &
REPERCUSSIONS.

ALL IN

Cashing in all of my chips
pushing 'em in 2 the middle of the table... & u can send out emails, tweets or see it on cable
tell the world - I'm all in.
Going for broke it's no joke
ace high flush is what I'm holding
there's no way I'm folding
playing the hand God dealt me &
I recommend u do the same
I'm in it to win this game.
So in the game of life
no matter what hand you're dealt...
if your goals are good,
you're passionate & purposeful
& your dreams & desires are all heart felt... Go all in -
because if you're in the game of life
with God on your side
go all in ...you'll always win.

THIS & THAT

...USE 2 BE SKINNY
USE 2 BE FAT –
HAD A LITTLE OF THIS
& A LOT OF THAT –
HAD IT ALL –
HAD A BALL OUT RUNNING WITH RATS –
BIG – LIKE A BOSS HOG
DOG EAT DOG

...UNTIL I CHANGED MY DIET,
CUT BACK ON MY SNACKS,
THE CARBS, THE BS & THE UNNECESSARY
FAT – EVEN CUT BACK ON THE THIS
& SLOWED DOWN ON THE THAT!
...FLIPPED THE SCRIPT
& NOW IT'S – THAT & THIS
MY DIET NOW CONSISTS...
OF PEACE & BLISS.

COUNT YOUR BLESSINGS
1,2,3...

10 FINGERS 10 TOES
2 EARS, 1 MOUTH... 1 NOSE –
GOOD ENOUGH 2 SMELL A ROSE
THESE THINGS ARE CONSIDERED THE
NORM - BUT REGARDLESS OF YOUR
CONDITION SHAPE OR FORM

GOD

HAS A PURPOSE 4 YOU
THAT IS ONLY HEAVENLY KNOWN
SO COUNT YOUR BLESSINGS
& LIVE ON...

TAKE THE "NOT" OUT

...AS IN THAT CAN NOT BE DONE
...AS IN THAT CAN NOT HAPPEN
...AS IN LET'S NOT TRY THAT.
LIKE A KNOT IN A WATER HOSE -
A NOT WILL STOP POSITIVE FLOW...
JUST LIKE A NOT IN THE MIND
CAN STOP NEW THOUGHTS & IDEAS
& THEIR ABILITY TO GROW.

HARD HEAD ED

...ON THE CORNER THEY CALLED HIM HARD HEAD ED - IT WAS SAID THAT WAS BECAUSE HE WAS AS STUBBORN AS A MULE – THE KIND OF CAT WHO LIVED BY HIS OWN SET OF RULES...
NEVER FOLLOWED THE CROWD HE WAS INDEPENDENT & PROUD WHEN OTHERS WERE OUT HAVING FUN - ED WAS MAKING MOVES TRYING TO GET THINGS DONE... WHEN OTHERS WERE RUNNING THE STREETS – ED WAS IN BED – SO HE COULD GET UP EARLY TO DO WHAT WAS NEEDED SO HIS FAMILY COULD EAT. HE'D SAY THE SAME THING EVERY DAY – HE WAS TOO BUSY TO GAMBLE & PLAY – HE HAD WORLDS TO CONQUER & DRAGONS TO SLAY – HE DIDN'T WANT TO BE LIKE HIS COUSIN FRED, WHO USE TO BE ON THE CORNER – BUT NOW HE'S DEAD –

ED HAD PLANS TO GET AHEAD — & BASED ON THE THINGS THAT HE KNEW & SAW — HE KNEW THAT WHAT HE HAD TO DO HAD TO BE WITHIN THE LIMITS OF THE LAW... SO INSTEAD OF SLINGING ROCK HE INVESTED — HE INVESTED IN HARD WORK & DETERMINATION, DREAMING BIG & INNOVATION... HE INVESTED IN BRINGING UNITY INTO HIS COMMUNITY & HELPING THOSE WHO COULD NOT HELP THEMSELVES... HE INVESTED IN HIS DREAMS & HE INVESTED IN HIMSELF & HE INVESTED IN SOME GOOGLE STOCK — NOW ED'S THE OWNER OF THAT BUILDING ON THE CORNER & NEARLY HALF THE BLOCK — WE SHOULD ALL LEARN FROM THE MOVES THAT HARD HEAD MADE — BECAUSE HE ENDURED THE SHADE & DIDN'T FADE — HELD TRUE TO HIS GOALS & BELIEFS & HE REALLY GOT PAID

DRIVE

AS LONG AS U KEEP GAS
IN YOUR TANK
IN THE FORM OF MOTIVATION
STAY BETWEEN THE LINES
IN RIGHTEOUS DETERMINATION
KEEP YOUR FOOT ON THE PEDAL
WITHIN LEGAL LIMITATIONS
YOU'LL GET TO WHERE YOU'RE GOING
- YOUR FINAL DESTINATION.
THE JOY'S IN THE JOURNEY
SO NEVER LET IT END - ENJOY THE
RIDE - BUT NEVER LOSE YOUR *DRIVE* -
BECAUSE U NEED IT TO SUCCEED
& YOU GOT TO HAVE IT...
TO SURVIVE.

LOOSEN UP

UNCLENCH YOUR TEETH
UNCURL YOUR TOES & REST YOUR FEET
RELAX - KICK BACK
HAVE A BEVERAGE & A SNACK
TAKE A NAP –
CLOSE YOUR EYES & TAKE A TRIP
TO PARADISE. WHY THE HASSLES, ANGER
& HATE? WHAT'S THE FUSS?
LOOSEN UP –
THERE'S ENOUGH PEACE

FOR ALL OF US.

CHAPTER IV

LONG STORY SHORT

POETRY/BARS/VERSES

I. CONNECTED
II. LOOKING FOR LOVE
III. ALL OF THE ABOVE
IV. AIRGASM
V. ALONENESS
VI. STATE OF MIND
VII. HOME
VIII. LIVING IN THE NOW
IX. MY BODY MY TEMPLE
X. GIVE IT YOUR ALL
XI. 'CAUSE CUZ
XII. IT IS WHAT IT IS
XIII. THE BREAKDOWN
XIV. SAY WHAT !

XV. THE +/- EQUATION
XVI. IT'S A FAMILY AFFAIR
XVII. LOVE IS ON THE MENU
XVIII. RESPECT
XIX. OUCH
XX. IN THE ZONE
XXI. THE TEST

XXII. DON'T LIE 2 ME
XXIII. REPRESENTATIVE
XXIV. K.I.S.S. ME
XXV. I KNOW THE WAY
XVI. TRU DAT
XXVII. NO GRUMBLES
XXVIII. LONG STORY SHORT
XXIX. BURDEN FREE

CONNECTED

I KNOW HOW TO BE STILL
DRAWING ENERGY FROM THE SUN
I KNOW HOW IT WORKS
I KNOW HOW THINGS RUN
PLUGGED IN CHARGED UP
CONNECTED TO THE VINE...

SHOWCASING MY TRUE COLORS –
BRANCHING OUT ALL THE TIME...
NATURALLY BLESSED
NATURALLY DRESSED
BOOTED, SUITED
& WELL ROOTED
& FEELING DIVINE

LOOKING FOR LOVE

(LOVE BLOOMS IN THE SPRINGTIME)

HAVE U SEEN HER -
THEY SAY HE HANGS OUT OVER
THERE - BUT SOMETIMES GOES
UPTOWN - SHE'S MOBILE TO -
SHE MOVES AROUND
ONE ON THIS SIDE -
THE OTHER OVER THERE
LOVE SEEMS TO BE ELUSIVE -
IT JUST AIN'T FAIR...
WHAT 2 DO - WHAT 2 DO -
WHAT 2 DO...
THEY'LL FIGURE IT OUT
THAT'S THE NATURE OF LOVE -
BECAUSE IF YOUR HEART IS PURE
AND YOUR INTENT IS TRUE -
U DON'T HAVE 2 GO LOOKING 4 LOVE -

LOVE WILL FIND U.

ALL OF THE ABOVE

...IF U COULD MAKE A SELECTION
FROM A COLLECTION
OF THINGS TO HELP LEAD THE WORLD
IN A MORE POSITIVE DIRECTION –
WOULD U USE YOUR VOICE
TO MAKE A CHOICE
FOR MORE:
(A) PEACE & BLISS
(B) JOY & HAPPINESS
(C) KINDNESS & LOVE

OR WOULD U BE LIKE ME
& PICK ALL 3 & CHOOSE -
ALL OF THE ABOVE

AIR-GASM

MY LUNGS
HAVE AN INTIMATE
RELATIONSHIP WITH *AIR*
EVERY TIME WE BREATHE -
WE MAKE SWEET LOVE 2 THE
UNIVERSE & WHEN WE BREATHE
VERY DEEPLY & EXHALE VERY
SLOWLY
WE COME TOGETHER
...*AS ONE.*

TRY IT...
U CAN'T LIVE
WITHOUT HER.

ALONE-NESS

...THERE'S A ONE-NESS IN BEING ALONE.
SOME VIEW BEING ALONE
AS A NEGATIVE SITUATION
BUT BEING ALONE WITH ONESELF
IS A MAJOR PART
OF SOLVING THE EQUATION...
BECAUSE IN THAT ALONE TIME -
YOU GET TO FIND THE THINGS THAT
REALLY IMPACT YOUR HEART AND
EFFECT YOUR MIND - AND WHEN YOU
TURN OFF THE NOISE AND ALL THE
MEDIA TOYS AND EXPERIENCE THE
SILENCE OF YOU AND NO ONE ELSE—
YOU DISCOVER WHO YOU REALLY
ARE...

IT GIVES YOU A CHANCE TO COMMUNE
WITH YOUR INNER-SOUL
SO TURN OFF THE TV
AND PUT DOWN THE REMOTE CONTROL
NO NEED TO EVEN GO TO THE STORE -
BECAUSE AT YOUR CORE
YOU CAN FIND EVERYTHING YOU NEED
AND A WHOLE LOT MORE –
WHEN YOU LEARN TO TRULY LOVE
YOURSELF
IN YOUR ALONE-NESS –
YOUR ONE-NESS
YOU DISCOVER YOUR BLISS,
YOUR JOY,
YOUR PEACE...
AND A SENSE OF
PURE HAPPINESS.

STATE OF MIND

...IS IT STATE OF MINE
OR STATE OF YOURS
IS IT OPEN BORDERS OR CLOSED
DOORS CLOSED MINDS IN CLOSED
SILOS REFUTING THE FACTS IN YOUR
OWN VIDEOS. WHAT'S THE FIGHT
EQUAL RIGHTS – CIVIL RIGHTS –
HUMAN RIGHTS - STATES RIGHT –
STATES LEFT DISSOLUTION OF THE
UNION – BLAME YOURSELF... STATE
WHAT'S ON YOUR MIND BUT LET'S
DRAW THE LINE AND LEARN TO
RESPECT AND LOVE EACH OTHER
...FROM TIME TO TIME.
PARTS DIVIDED CANNOT BE WHOLE -
LET'S LEARN TO LIVE TOGETHER
...*SOUL TO SOUL.*

H**OM**E

LOOKING FOR
A HEAVENLY ENVIRONMENT
A PLACE OF PEACE AND SERENITY...
JUST SAY THE WORD
HOME
- AND LET IT HUM -
THEN SIT BACK AND RELAX
AND THE PEACE WILL COME.

DOROTHY SAID IT BEST
IN THE WIZARD OF OZ
...THERE'S NO PLACE LIKE

OM.

LIVING IN THE
NOW

...WHAT HAD HAPPENED WAS -
IS WHAT SOME FOLKS ARE PRONE TO
SAY... WHEN ATTEMPTING TO
EXPLAIN SOMETHING THAT MAY
HAVE HAPPENED YESTERDAY.
BUT WHAT HAD HAPPENED -
HAPPENED BECAUSE
IN THE UNIVERSAL ORDER OF THINGS -
IF IT HAPPENED IT HAPPENED
BECAUSE IT WAS DESTINED TO
HAPPEN THAT WAY.
AND AS OUR WISDOM HEIGHTENS
AND WE BECOME MORE
SPIRITUALLY ENLIGHTENED

*We learn to focus on
where we are here and now -
and give thanks and gratitude
for all we have today.
No need to attempt to
relive the past
No need to try to rectify
with excuses – lies – or alibis
And no need to question
why or how –
Just accept what had happened...
and live in the present -
because
that was then
and this is now.*

MY BODY MY TEMPLE

WATCH WHAT YOU EAT!
TOO MANY SUGARY SWEET TREATS
TOO MUCH LIQUOR, DRUGS & PROCESSED
MEAT WILL HAVE YOU WALKING AROUND
LIKE A ZOMBIE – DEAD ON YOUR FEET
ARTERIES CLOGGED – MIND IN A FOG
ALWAYS COMPLAIN'N & SICK AS A DOG.
IF YOU INGEST LESS THAN THE BEST
THE WRONG DIET CAN BE JUST LIKE AN
ADDICTION & THE PRIMARY CAUSE
OF YOUR MEDICAL AFFLICTIONS.
BECAUSE THE OVERUSE & ABUSE
OF THE WRONG FOODS & SUBSTANCES
AS A MEANS TO COPE -
WILL EVENTUALLY WEAR THIN
& IN THE END...
MAKE YOU THE DOPE.

GIVE IT YOUR ALL

WHEN THE RAINS FALL & THE FLOOD
COMES... TO TURN THE TIDE –
BE SURE TO FOLLOW YOUR SPIRITUAL
GUIDE & BE LIKE NOAH AND BUILD YOU
AN ARK FIND YOUR SPARK
& GET YOUR PLAN TOGETHER –
GET YOUR CLAN TOGETHER –
SO YOU ALL CAN FLOAT BE THE B.O.A.T.
(BEST OF ALL TIME) BE PREPARED TO
USE YOUR BODY & YOUR MIND
BE PREPARED TO DELIVER
KEEP A SHARP ARROW IN YOUR QUIVER...
BE PREPARED TO SWIM GET IN THE GYM &
BUILD UP YOUR SPIRITUAL MUSCLE
BE PREPARED FOR THE TUSSLE
BE PREPARED TO FLY –
BE PREPARED TO SOAR
LIKE A BIRD IN THE SKY...
& AFTER ALL IS SAID & DONE...
BE SURE TO LIVE – BEFORE YOU DIE

'CAUSE CUZ Y

CUZ WE RELATED
'CAUSE MY FATHER
& YOUR FATHER'S
FATHER IS THE SAME FATHER
& WE ALL HAVE THE SAME NATURE
AS OUR MOTHER
MAKING US ALL
JUST LIKE EACH OTHER
SISTER OR BROTHER
OR CUZ
SAME BLOOD -

THAT'S Y
THAT'S THE CAUSE CUZ

PEACE & LOVE

I'M OUT.

IT IS
WHAT IT IS

INTELLECTUALS DEFINE <u>LIFE</u>
AS A SERIES OF SCIENTIFIC EQUATIONS
& MATHEMATICAL CALCULATIONS

SPIRITUALISTS SAY IT'S ALL ABOUT
ONENESS AND UNIVERSAL UNIFICATION
REGARDLESS OF HOW YOU DEFINE
THE GAME OR THE REASON,
RATIONAL OR NAME -
THE END RESULT IS ALL THE SAME...

AND UNDERSTANDING
IT IS WHAT IT IS
IS NOT THAT HARD....
BECAUSE WHAT IT IS

<u>IS GOD</u>

THE BREAK DOWN

GOT AN ISSUE THAT NEEDS REPAIR?
STAY AWARE -
& KEEP YOUR MIND ON THE *GOD IN U*
AND WITH GOD IN THE MIX
IT'S EASILY FIXED
THAT'S ALL U HAVE 2 DO.
IF U DIDN'T KNOW THEN – U DO NOW
U JUST GOT SCHOOLED
ROUSED FROM YOUR DROWSE
INTRODUCED 2 THE RULE & HERE'S HOW.
2 MAKE IT ALL COME TRUE
JUST DO THE MATH
FOLLOW THE RIGHT PATH
& KNOW WHO 2 ASK & WHO 2 TURN 2
& IT'S EASY 2 FIX
WHAT'S BEEN BROKE
JUST STAY WOKE... &
KEEP YOUR FOCUS ON
THE *GOD IN U.*

SAY WHAT!!

MAKE YOURSELF A GOOD
AND AS INTERESTING A PERSON
AS POSSIBLE IN YOUR EARLY YEARS
BECAUSE LATER ON WHEN U BEGIN
TALKING 2 YOUR SELF
YOU'LL HAVE A FUN AND STIMULATING
CONVERSATION WITH NO HANGUPS
RESERVATIONS OR FEARS
& IF U DO IT WITH YOUR LIPS CLOSED
YOUR HEART OPEN
& YOUR CONSCIENCE CLEAR...
GUESS WHAT U HEAR –
COMING OUT OF U...

THE VOICE OF GOD
CLEAR & TRUE.

THE +/-
(POSITIVE/NEGATIVE) EQUATION

BEWARE OF PRETEND FRIENDS
WHO TRY TO STEAL YOUR JUICE
JUST TO GIVE THEIR EGO A BOOST...
WHO WILL GO TO ANY LENGTH
TO SAP YOUR STRENGTH
& WHO WILL WORK LIKE THE DEVIL
TO BRING U DOWN TO THEIR LEVEL...
DON'T RUN FROM THEM OR SHUN THEM
WORK TO OVERCOME THEM
WITH YOUR POSITIVE VIBES
HELP THEM TO BECOME A MEMBER
OF YOUR SPIRIT TRIBE...
SHOW THEM WHAT IT'S ALL ABOUT
WHEN YOU LIVE AND BREATHE
FROM THE INSIDE OUT
AS A SHINING LIGHT
BEAMING WITH THE GLOW OF GOD
ALL DAY & ALL NIGHT

IT'S A FAMILY AFFAIR

...WHO WAKES THE ROOSTER
TO START THE DAY OFF WHO MAKES THE
GROUND FIRM & THE CLOUDS SOFT...
THE ROOSTER CROWS WHEN THE SUN RISES
ALERTING US TO A BRAND-NEW DAY
FILLED WITH JOYOUS SURPRISES...
A NATURAL CLOCK
THAT SETS THE DAY IN MOTION...
LIKE THE EBB & FLOW OF THE TIDES
& THE WAVES OF THE OCEAN...
ASK THE ROOSTER AS IT BEGINS TO CROW
& IT WILL TELL YOU IT'S THE FATHER &
MOTHER NATURE & THEIR GLORIOUS SUN
(A FAMILY WE ALL BELONG TO – A FAMILY
OF ONE) THAT WAKES US UP - TO GET
GOD'S WORK DONE THAT'S WHAT STARTS
THE SHOW... NOW YOU KNOW
WHAT MAKES THE ROOSTER CROW.

LOVE IS ON THE MENU

...TAKE THE PRESSURE OFF MY PLATE
TAKE SOME TIME TO CONTEMPLATE
THE DIFFERENCE BETWEEN
LOVE & HATE.
ONE BRINGS U DOWN
ONE LIFTS U UP
ONE DRAINS THE HEART,
THE SOUL THE BRAIN
THE OTHER FILLS YOUR CUP...
TAKE THE PRESSURE OFF MY PLATE...
I'LL HAVE AN EXTRA ORDER OF
LOVE
HOLD THE HATE

RESPECT

...THE BIBLE SAYS
GOD IS A RESPECTER OF NO MAN –
I CAN ACCEPT THAT
IT ALSO SAYS THE SPIRIT OF GOD
RESIDES IN US ALL –
I MUST ACCEPT THAT TOO
SO FROM THAT POINT OF VIEW
IT'S A GIVEN THAT U RESPECT ME
JUST AS MUCH AS I MUST RESPECT U.
SO REGARDLESS OF ONE'S STYLE
SHAPE OR LOOKS -
FREE YOUR MIND
FROM THE PRISON
OF BEING JUDGMENTAL
& ALWAYS SEE **THE GOD** IN THEM
& PUT SOME **RESPECT**
ON THEIR BOOKS.

OUCH!

FORGIVE ME...

IF I STEPPED ON YOUR TOE
DID IT BLEED – DID IT HURT
OR DID IT JUST BRUISE YOUR EGO
DID WE BREAK THE SKIN
DID I LOSE YOU AS A FRIEND
I APOLOGIZE IF IN YOUR EYES
I HURT YOUR FEELINGS
& BETRAYED YOUR TRUST
BUT THESE ARE THE TIMES
THAT SHOULD BRING OUT...
THE BEST IN US
& SHOW THERE'S A GOD & A GOODNESS
IN THE SIMPLE ACT OF FORGIVENESS
& THAT TRUE LOVE
IS ALWAYS BIGGER THAN A BRUISED EGO
OR A STEPPED-ON TOE
SO LET ME KNOW... WHEN YOU'RE
READY TO GET PASS PETTY
& LET IT GO.

IN THE ZONE

DON'T BE AFRAID TO GIVE IT A SHOT
& SPEND SOME QUIET TIME ON YOUR OWN
– ALL ALONE –
YOU'LL FIND NO ONE THERE BUT U –
SO DON'T BE AFRAID OR UNAWARE
OF THE THINGS U THINK OR DO...
TAKE THE TIME TO CLEAR YOUR MIND
& FRESHEN UP YOUR THOUGHTS
& FORGET ABOUT OLD PAINS & MENTAL
STAINS & OLD BATTLES STILL BEING
FOUGHT... A GOOD TIME TO CLEAN UP
YOUR INTERNAL ENVIRONMENT
& COME TO TERMS WITH YOUR TRUE
SPIRITUAL EMPOWERMENT...
& REMEMBER WHAT'S REALLY REAL
& WHAT TO FEEL & HOW TO DEAL
WITH THAT AND THIS...
WHEN U COME TO KNOW & REALIZE
THAT WITH GOD AS YOUR COACH
YOU'LL NEVER EVER MISS.

THE TEST

THE UNIVERSE WILL SOMETIMES
USE A FOOL AS A TOOL
TO TAKE US BACK TO SCHOOL
TO TEST OUR KNOWLEDGE OF HOW
TO LIVE A LIFE INSPIRED BY THE GOLDEN
RULE – OF HOW TO LOVE EACH OTHER
KNOWING WE ARE ALL SISTERS AND
BROTHERS... EQUIPPED WITH THE
KNOWLEDGE TO TRANSCEND
SELFISH NEEDS AND PERSONAL GREED
AND HOW TO LOVE AND RESPECT
THE PRESENCE OF ANOTHER...
WE ALL HAVE THE KNOW HOW
TO SHOW HOW – ITS DONE

WE ALL HAVE THE ANSWERS TO WHO WE MUST BECOME ARMED WITH THE ASSURANCE THAT IT IS ALREADY WRITTEN - WE'VE ALREADY WON AWAKENED TO THE KNOWLEDGE WE ALREADY HAVE A MASTER'S DEGREE FROM GOD'S SPIRITUAL COLLEGE *WE'VE PASSED THE TEST -* AND THEREFORE WE WILL ALWAYS BE *PROMOTED, PROTECTED AND BLESSED.*

DON'T LIE 2 ME

...THAT'S NO LIE – ASK A LIAR
THEY'LL TELL U THAT'S TRUE
THEY HAVE NO REASON 2 LIE –
THEY JUST DO
IT'S IN THEIR NATURE –
THAT'S TRUE & THAT'S NO LIE
WHY WOULD THEY LOOK U DEAD IN THE
EYE & TELL U ANYTHING LESS THAN THE
TRUTH - CONFUSED - SO AM I -
& THAT'S NO LIE.
* THESE STATEMENTS HAVE NOT BEEN
FULLY CLARIFIED, VERIFIED NOR HAS THE
VERACITY OF THE TELLER OF THIS STORY
** BELIEF IS OPTIONAL
BUT FAITH & TRUST
IN THE WORD OF GOD ...AS A GUIDING
LIGHT
IS TRULY MANDATORY
(THAT'S NO LIE - BELIEVE ME)
- IN THE NAME OF ALL THAT'S HOLY –

REPRESENTATIVE

...CAN I GET SOME ASSISTANCE
ON THIS LINE
I'VE GOT SOME ISSUES ON MY MIND –
BUT I KEEP GETTING A RECORDING
THAT SAYS PRESS ZERO, 1 OR 9.
REPRESENTATIVE!
CAN I GET SOME HELP HERE –
THE PRERECORDED INSTRUCTIONS
JUST AREN'T CLEAR.
REPRESENTATIVE!
WHY IS THIS SO HARD...
I DON'T WANT TO TALK
TO ANOTHER AGENT –
GET ME THE SUPERVISOR...
I WANT TO SPEAK DIRECTLY
TO **GOD.**

K.I.S.S. ME
(KEEP IT SIMPLY SPIRITUAL)

...WITH PEACE & LOVE, PEACE & LOVE WITH THIS FEELING CONSTANTLY IN OUR HEARTS & MINDS WE'LL ALWAYS BE MORE IN TUNE WITH THE THOUGHTS & TEACHINGS OF THE DIVINE. SOME OF U MAY STILL THINK OF K.I.S.S. IN ANOTHER WAY – BUT THIS IS A BRAND NEW DAY – TIME TO THINK IN A BRAND NEW WAY – TIME TO TURN THE PAGE & PREPARE FOR A NEW GOLDEN AGE FILLED WITH PEACE & LOVE, PEACE & LOVE, FOR EVERY MAN WOMAN & CHILD... TIME TO REPROGRAM OUR MINDS & MODIFY OUR STYLE... & LET THOUGHTS OF LOVE & PEACE – NEVER CEASE BY KEEPING IT SIMPLY SPIRITUAL & ALWAYS BEING IN LINE WITH THE DIVINE... SO LET'S NOT KEEP BEING STUPID – K.I.S.S. ME (THIS IS MORE THAN JUST A PLAY ON WORDS KEEP IT SIMPLY SPIRITUAL
IT'S TIME.

I KNOW THE WAY

... WHEN I'M OUT & ABOUT
I TAKE THE SCENIC ROUTE,
THE ONE FILLED WITH FLOWERS & TREES
BIRDS & BEES THE ONE WITH THE NICE
COOL BREEZE THE ONE WHERE I CAN SEE
& FEEL GOD IN ACTION... THE ONE THAT
BRINGS ME SERENITY, PEACE, JOY &
EMOTIONAL SATISFACTION...
THE ONE WHERE THE STREETS SEEM TO BE
PAVED WITH GOLD WITH NO CURVES OR
BUMPS TO SLOW DOWN MY JOURNEY OR
DETOUR MY SOUL
THE ONE THAT PROVIDES ME
WITH A DIRECT LINE TO THE DIVINE -
I ALWAYS ENJOY MY JOURNEY THRU GOD'S
HOUSE I NEVER GET LOST - WITH NO
BRIDGES TO CROSS & NO TOLL TO PAY -
THAT'S WHY WHEN I'M OUT & ABOUT I
TAKE THE SPIRITUAL ROUTE.
FOLLOW ME... **I KNOW THE WAY**.

TRU 👍 DAT

...AS WE GO

AS WE GROW

& OUR PATHS

COINCIDE

COLLIDE – DIVIDE

... ALWAYS KNOW

I LOVE U SO -

& I'M ALWAYS

ON

YOUR SIDE

NO GRUMBLES

...WHEN I LOOK AT THE BLESSINGS &
LESSONS LIFE HAS GIVEN ME –
THRU THE GOOD – THE BAD
THE HAPPY & THE SAD
ALL I SEE...
IS SHARING & CARING
LOVE, JOY, PEACE
HAPPINESS & BLISS ...
BUT I DON'T SEE
GRUMBLES ON MY LIST.
MAINTAINING
WITHOUT
COMPLAINING...
I'M GRUMBLE FREE.
LIVING A LIFE OF GRACE
NO GRUMBLES
FOR ME

LONG STORY SHORT

BREAKING NEWS

I HAVE A MESSAGE TO DELIVER
& INFORMATION TO REPORT...
SHOULD WE KEEP THE STORY SHORT
OR MAKE A SHORT STORY LONG...
SHOULD WE PUT IT IN A POEM
OR SING IT IN A SONG...
SHOULD WE QUOTE IT FROM THE VERSES
OF THE QUR'AN, THE TORAH
OR THE BIBLE...
OR SHOULD WE PUT IT IN A NEW BOOK
WITH A BRAND-NEW TITLE
OR SHOULD WE DEPEND ON OUR BETTER
ANGELS TO BRING US UP TO SPEED
OR DO LOOK ONLINE FOR A NEW TEXT
OR THE LATEST DIGITAL FEED
OR BETTER YET

DO WE LOOK INTO OUR SOULS & SPIRITS
FOR WHAT WE REALLY, REALLY NEED.
BECAUSE FROM THE BEGINNING OF TIME –
BE IT IN A SONG, A HOLY VERSE
OR A NURSERY RHYME –
THE GOAL OF THE SOUL
REMAINS THE SAME...
TO GET LIFE'S BEST –
YOU HAVE TO GIVE IT YOUR BEST
LOVE THY NEIGHBOR
AS THY LOVE THY SELF
& GOD & THE UNIVERSE
WILL TALKE CARE OF THE REST.

SHORT STORY LONG –
LONG STORY SHORT
THAT'S THE MESSAGE
I HAD TO DELIVER
THAT'S THE END OF MY REPORT.

BURDEN FREE

(EQUATION 4 ETERNAL LIFE)

...REPEAT AFTER ME
I CAST MY BURDENS
ON THE CHRIST WITHIN
...*& I GO FREE* –
2 LIVE A LIFE OF LOVE,
JOY, PEACE
HAPPINESS & HARMONY.
REPEAT THIS OFTEN
MORNING, NOON & NIGHT
FOR WHATEVER YOUR ISSUE
FROM HEALTH 2 WEALTH
SAY IT WITH CLARITY & SINCERITY
&
EVERYTHING WILL BE ALRIGHT.

IN THE NAME OF THE FATHER
(THE UNIVERSAL GOD),
THE SON
(THE CHRIST/SPIRIT OF GOD IN YOU)
& THE HOLY GHOST
(GOD IN ACTION).

LIVE LONG & PROSPER.

AMEN

WWW.BIGARTPRODUCTIONS.COM

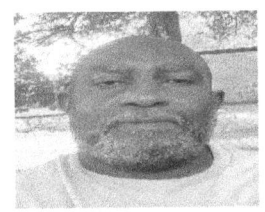

VINCENT LEE (VL) BENJAMIN IS A WRITER, POET, ENTREPRENEUR & PHILANTHROPIST WHO WRITES FROM THE PERSPECTIVE OF A SPIRITUAL BEING HAVING A JOYFUL HUMAN EXPERIENCE. ENJOY YOUR JOURNEY AND SHARE THE LOVE.

© VL BENJAMIN
BIG ART PRODUCTIONS

www.ingramcontent.com/pod-product-compliance
Lightning Source LLC
Chambersburg PA
CBHW072052230526
45479CB00010B/689